Johanna Basford

Johanna's Christmas

A Festive Coloring Book

PENGUIN BOOKS

PENGUIN BOOKS

An imprint of Penguin Random House LLC

375 Hudson Street

New York, New York 10014

penguin.com

ISBN 9780143129301

Printed in the United States of America

1 3 5 7 9 10 8 6 4 2

Interior designed by Johanna Basford
and Sabrina Bowers

This book belongs to

Parker

Introduction

Celebrate the festive season with a splash of color! From ornate tree decorations to deliciously decorated gingerbread houses and tangles of holly and ivy, *Johanna's Christmas* is a treasury of inky artwork for you to color, embellish and share.

In this book, you'll find 37 images you can easily remove—perfect for sending as a holiday greeting or even for framing!

Tips for
Johanna's Christmas:

◈ Use the blank page at the back of this book to test your pencils and pens.

◈ Pencils are the most versatile medium for coloring and will allow you to mix and blend your colors.

◈ Pens will give you a vibrant pop of color, but don't press too hard, and remember to test them before you dive in!

◈ Don't worry if you go over the lines.

◈ Share your creations with a friend or post a picture on social media with the hashtag #JohannasChristmas. It's fun to show off your masterpieces!

Hidden within the pages of this book is a flock of 63 elusive robins. Can you spot them all?

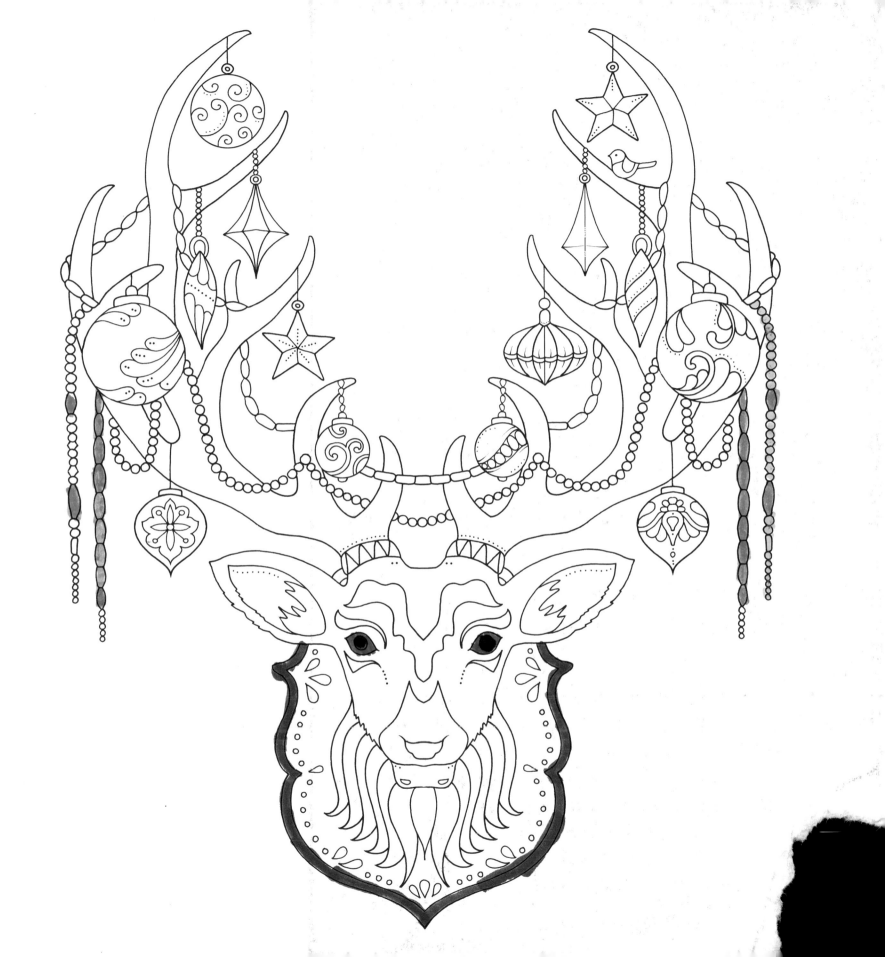

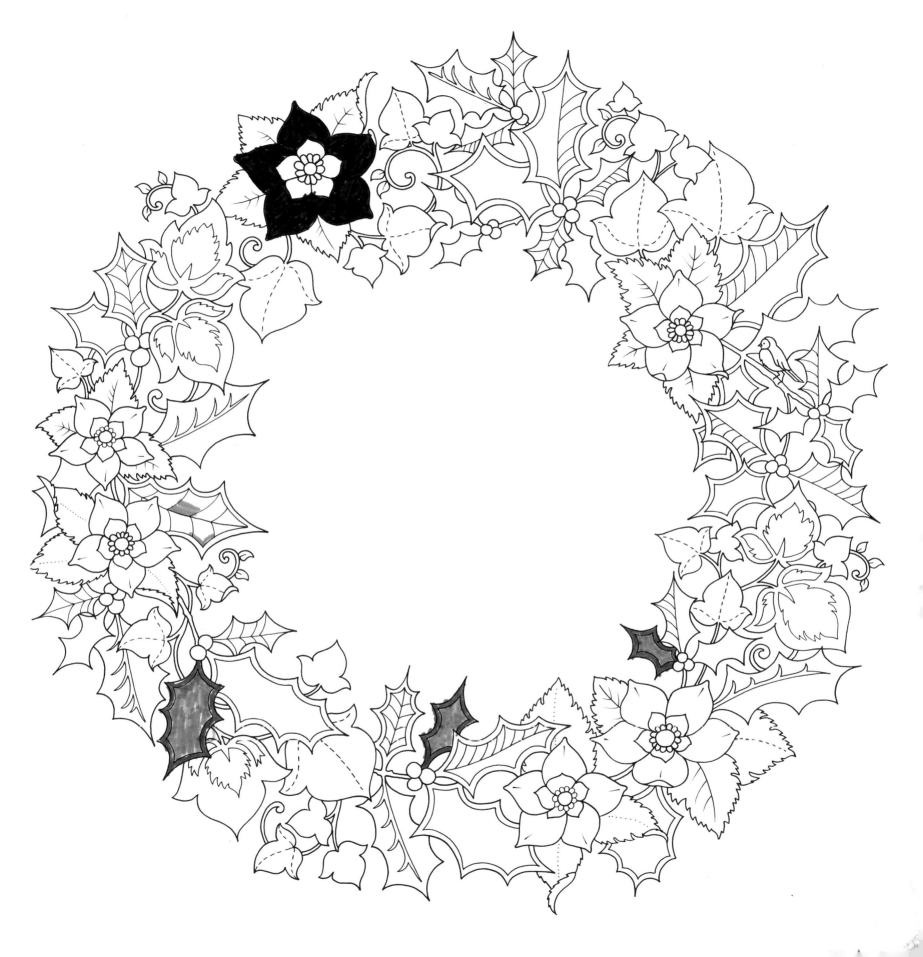

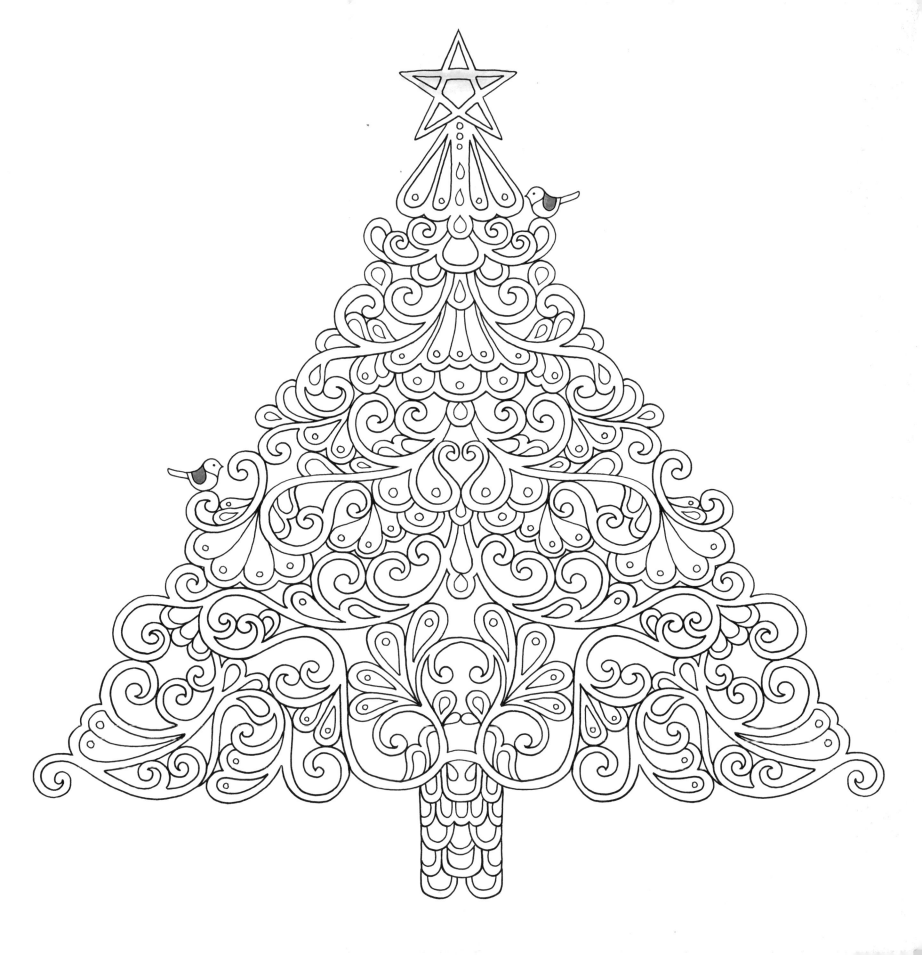

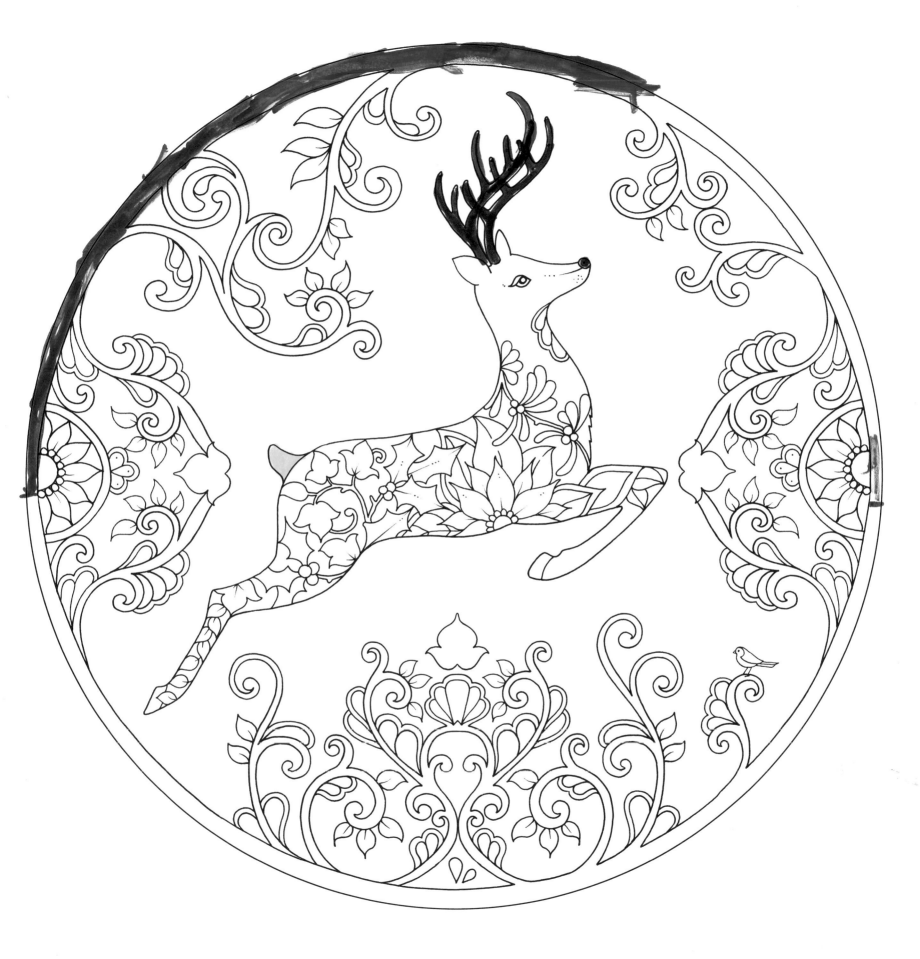

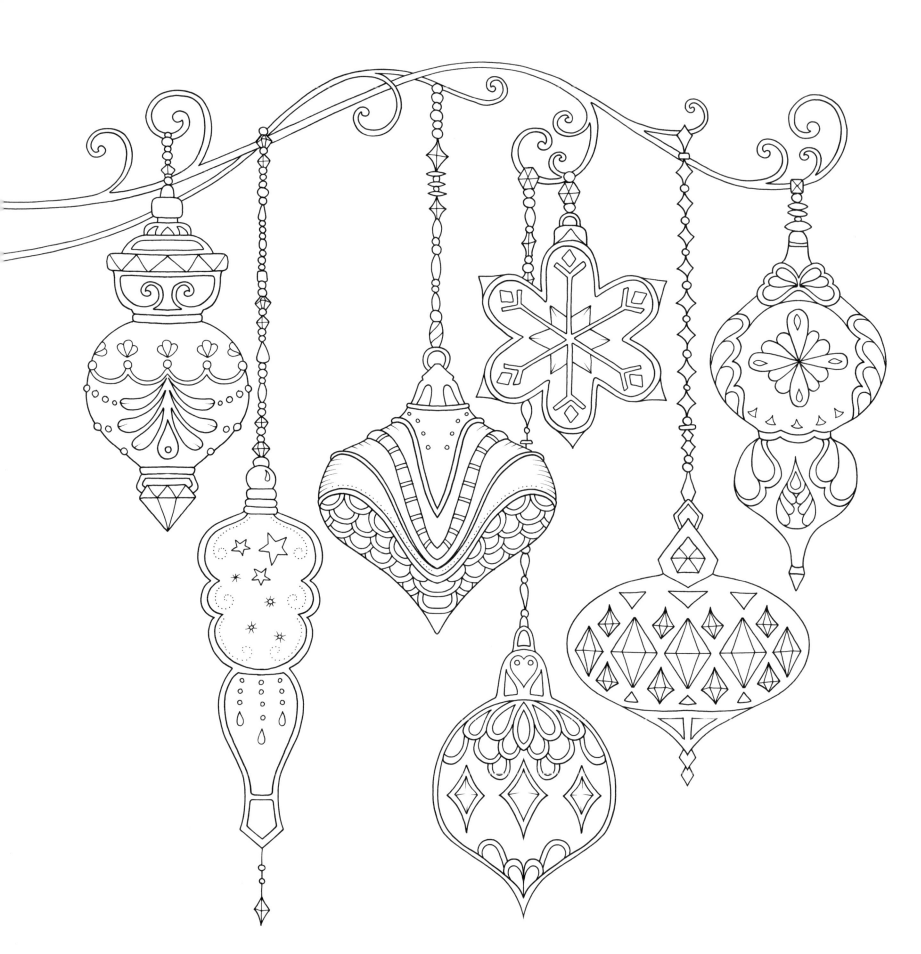

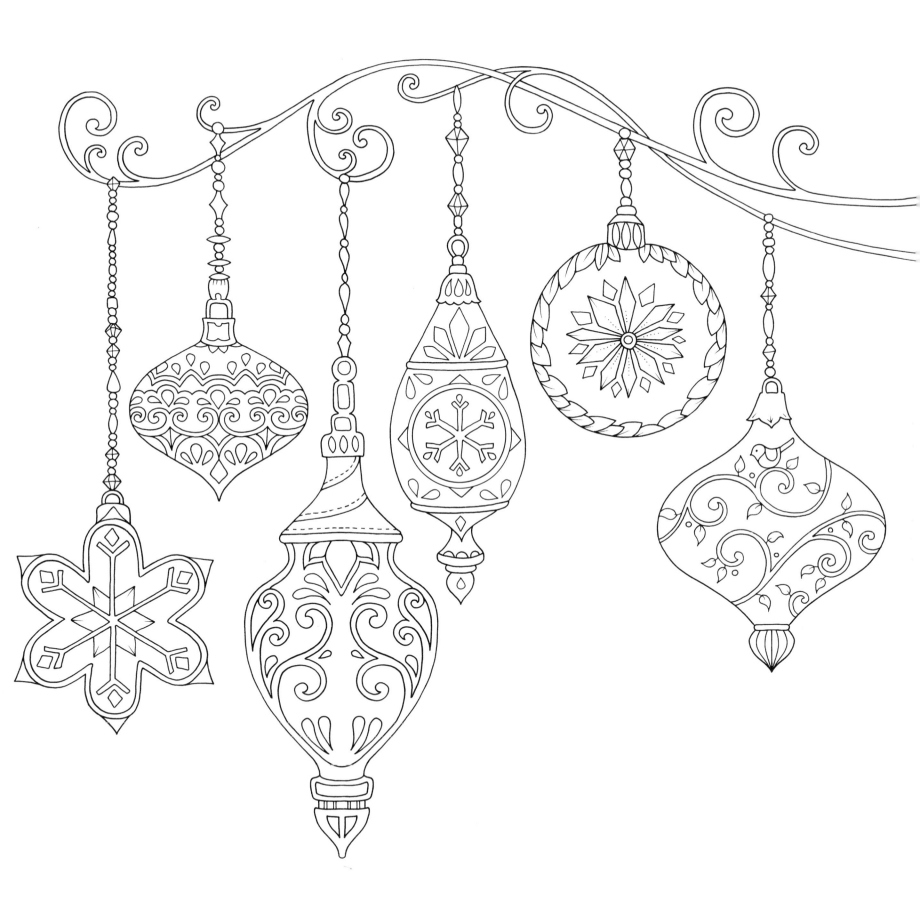

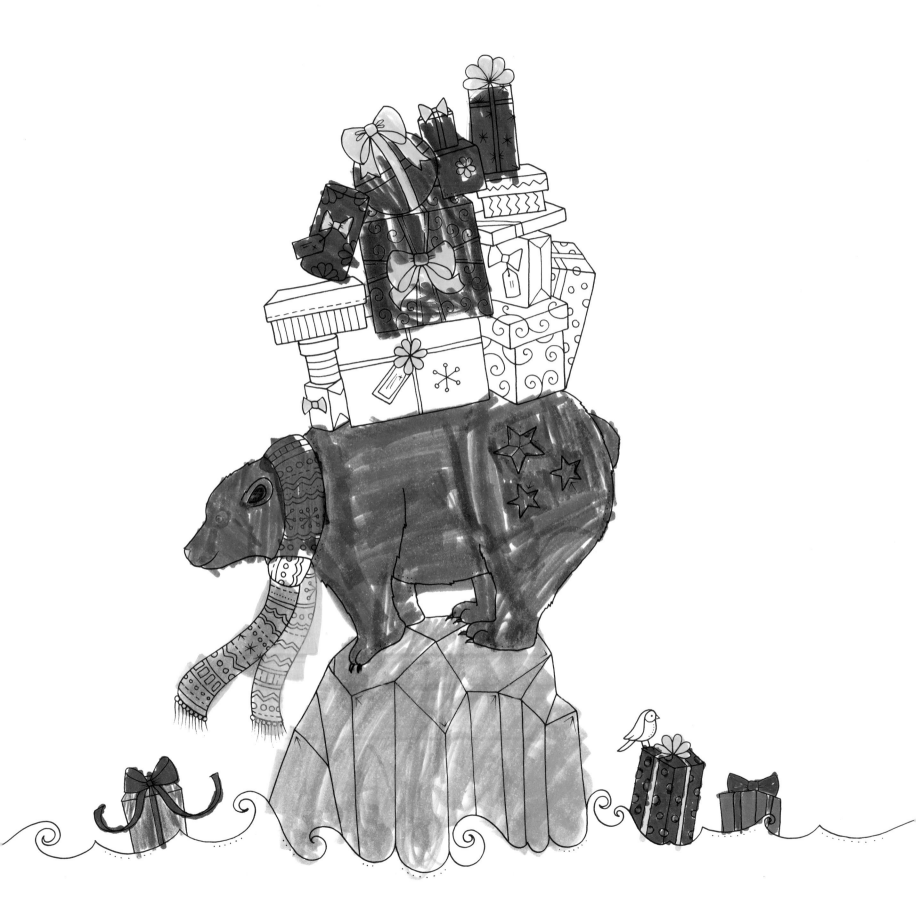

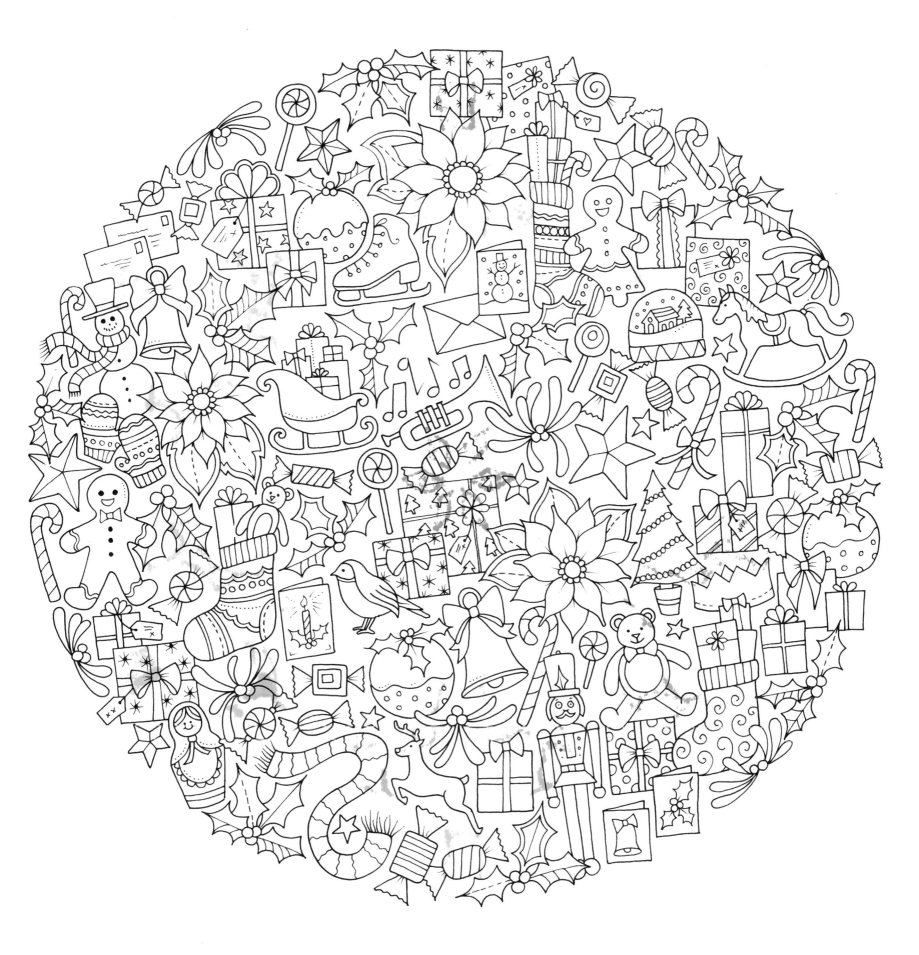

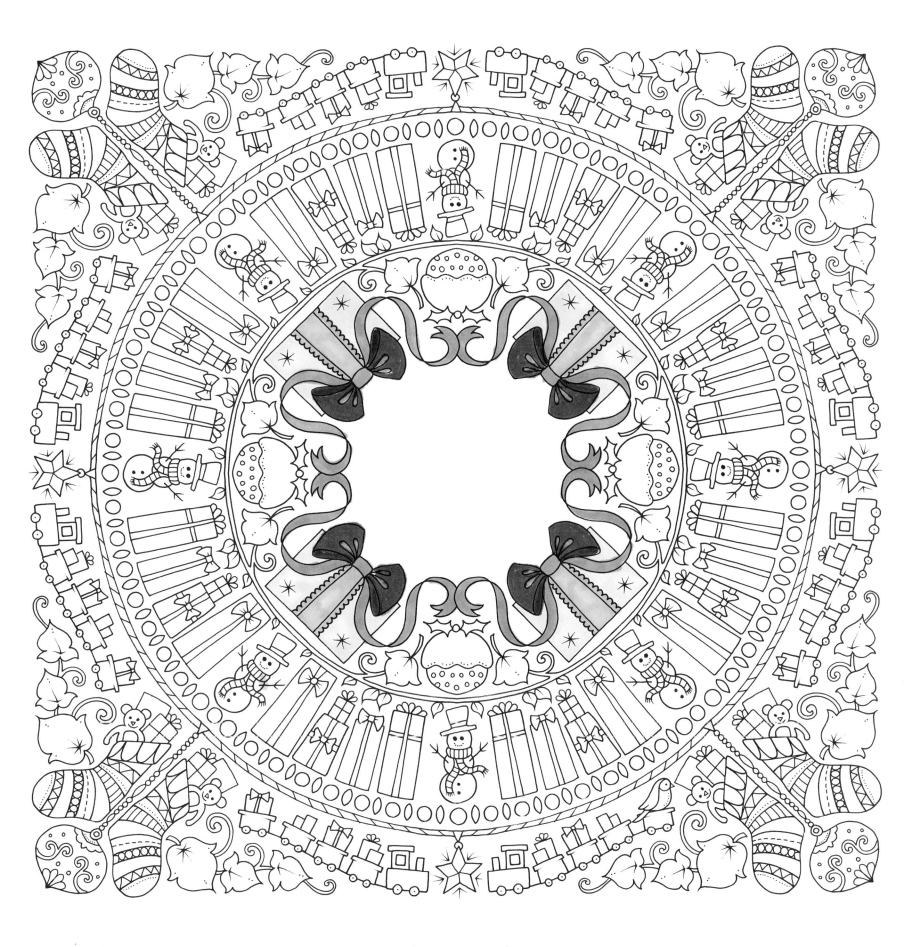

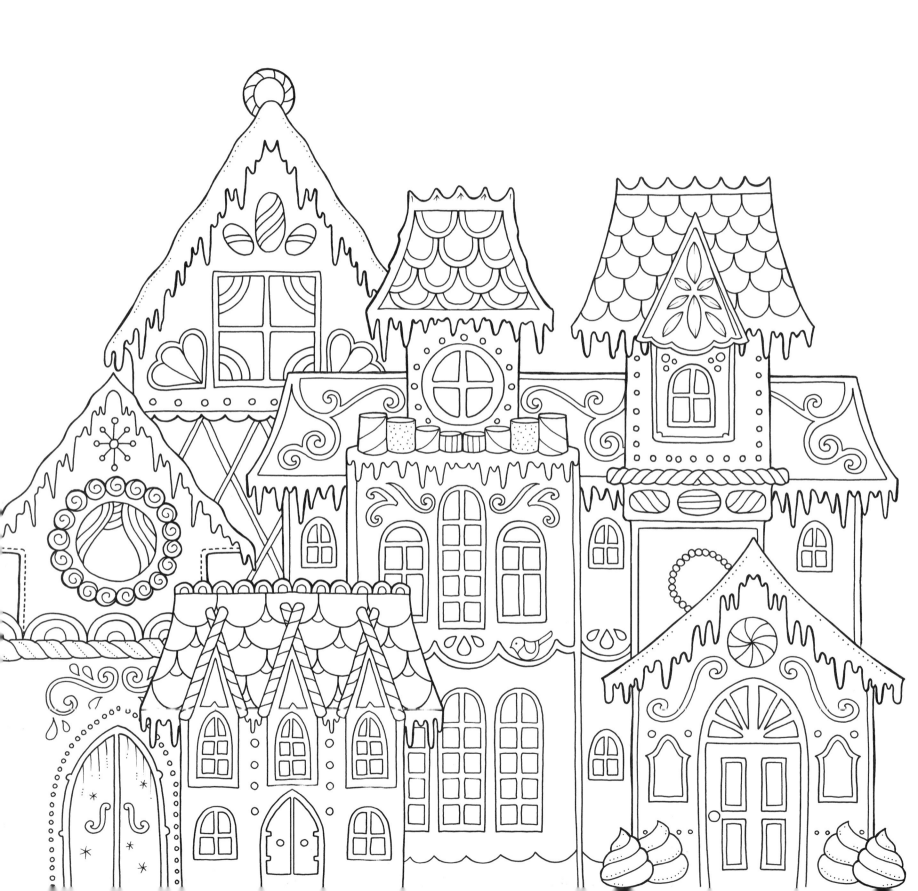

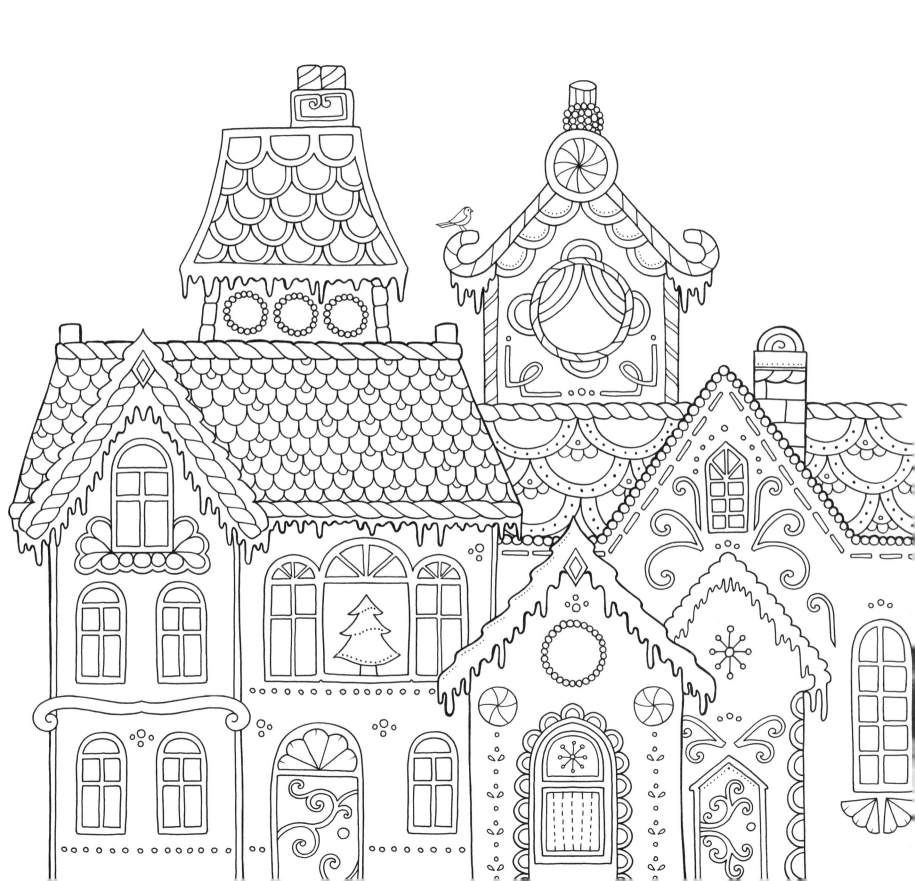

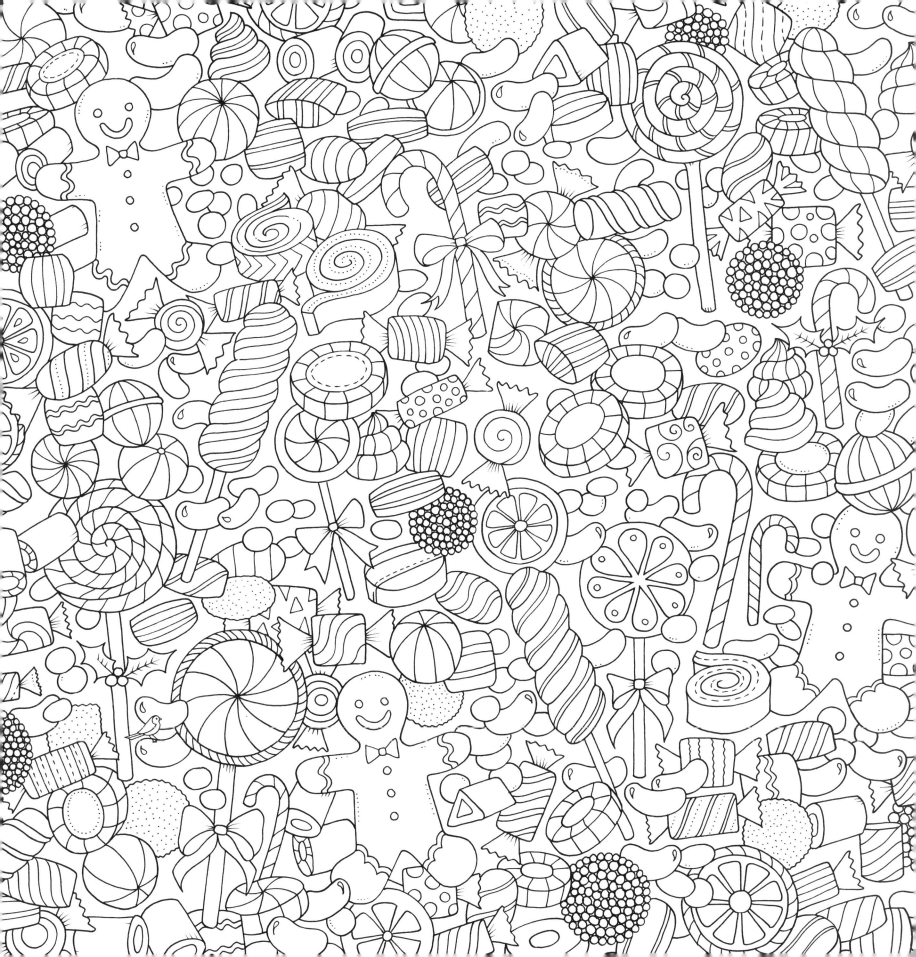

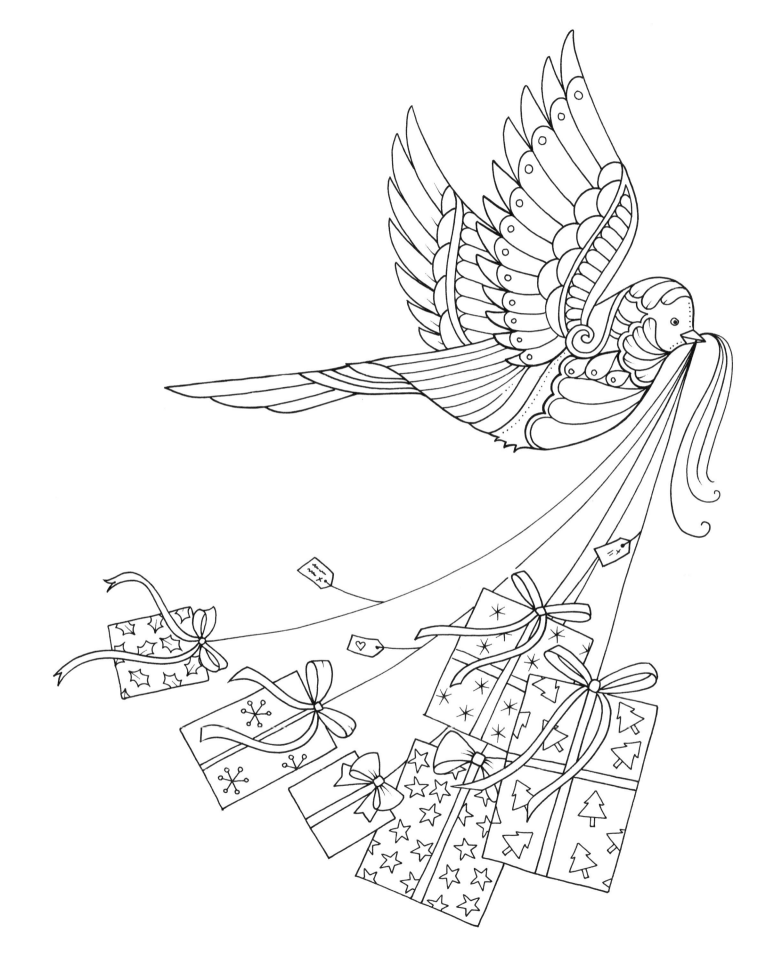

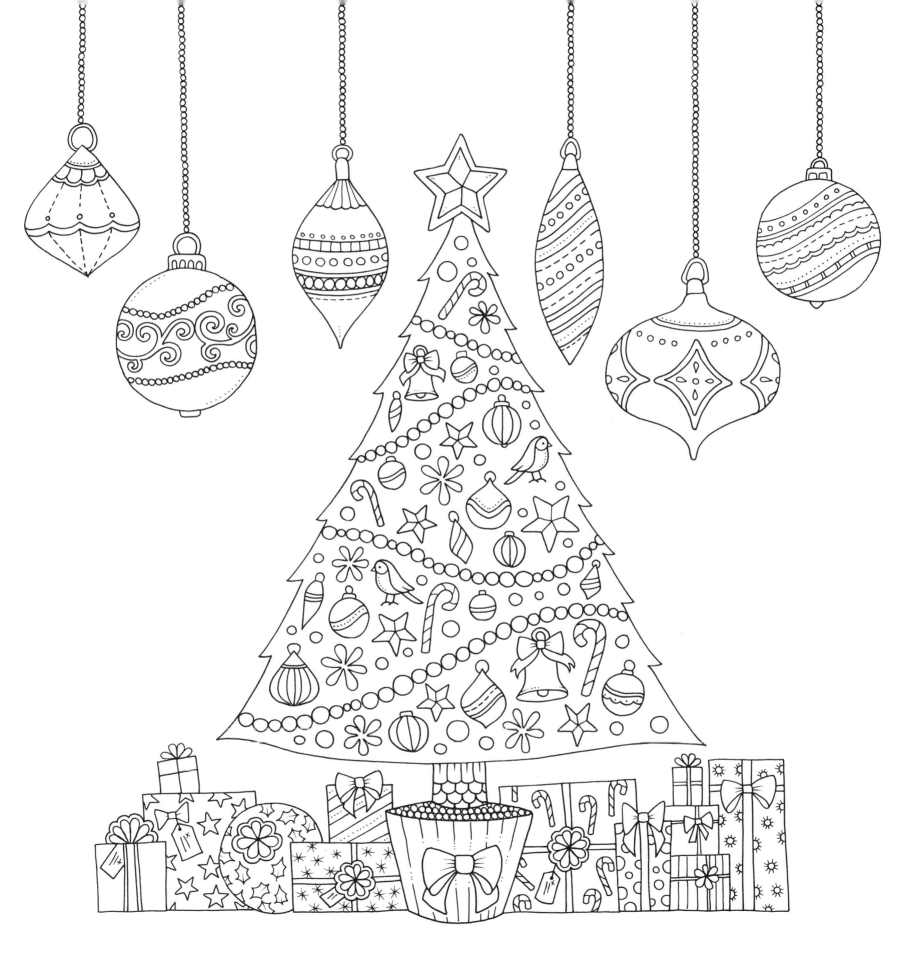

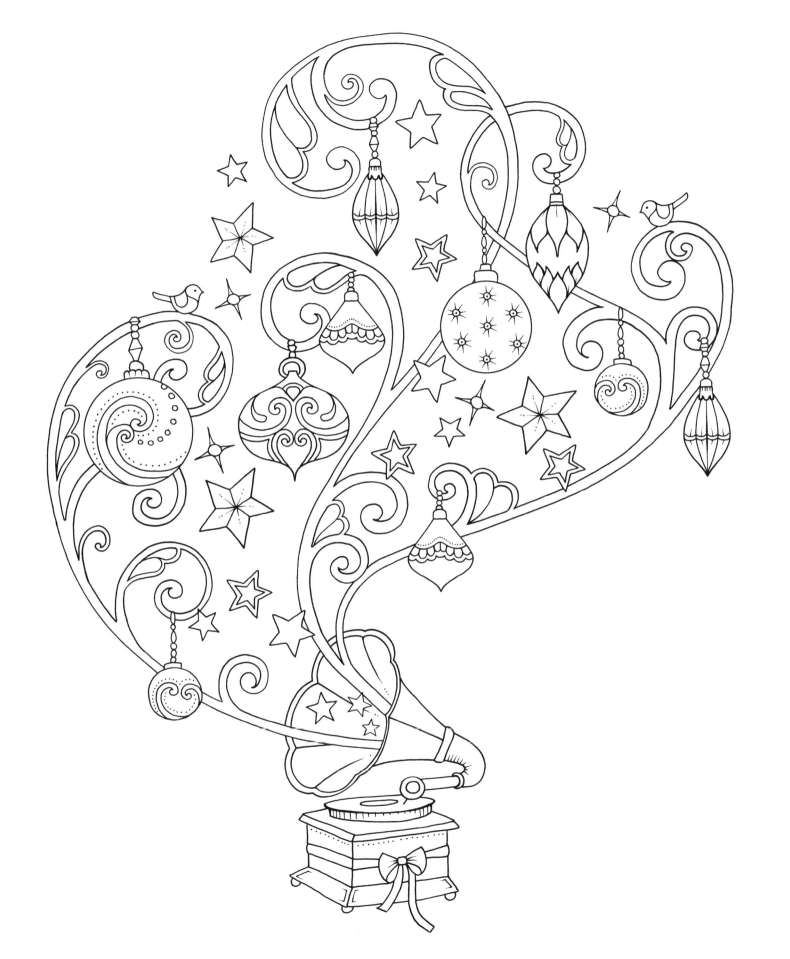

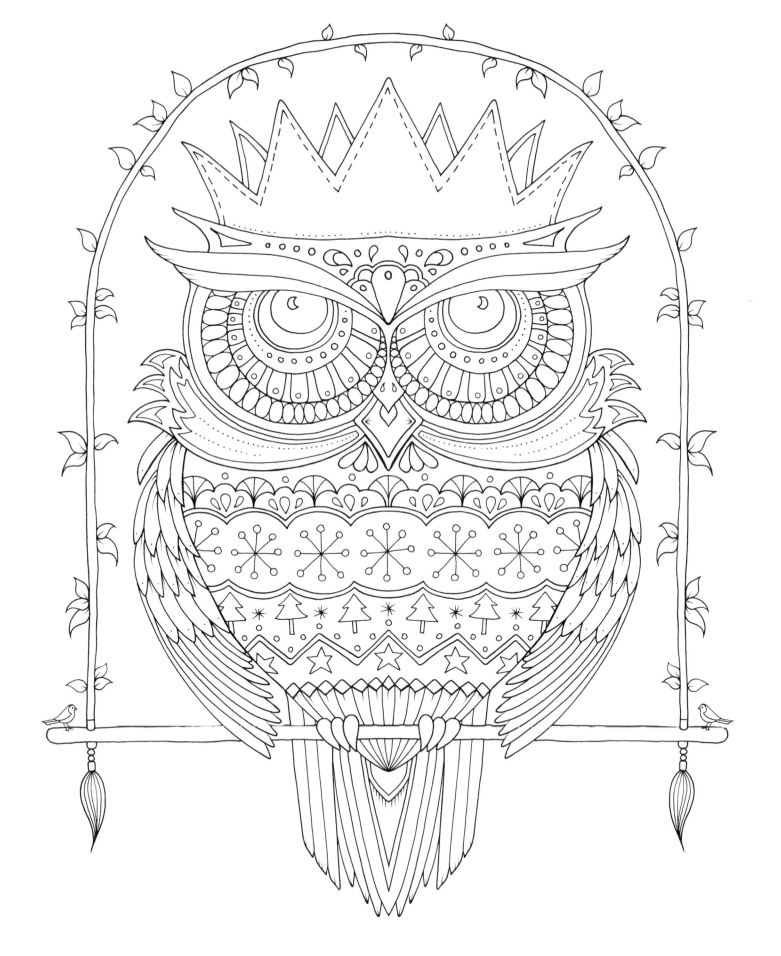

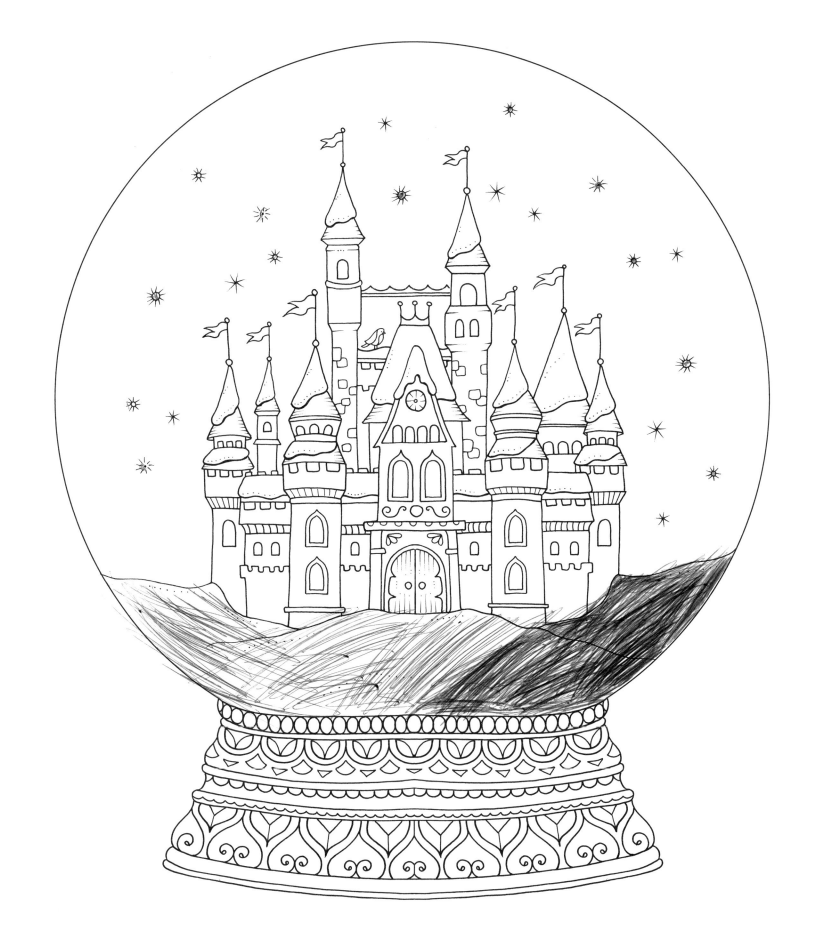

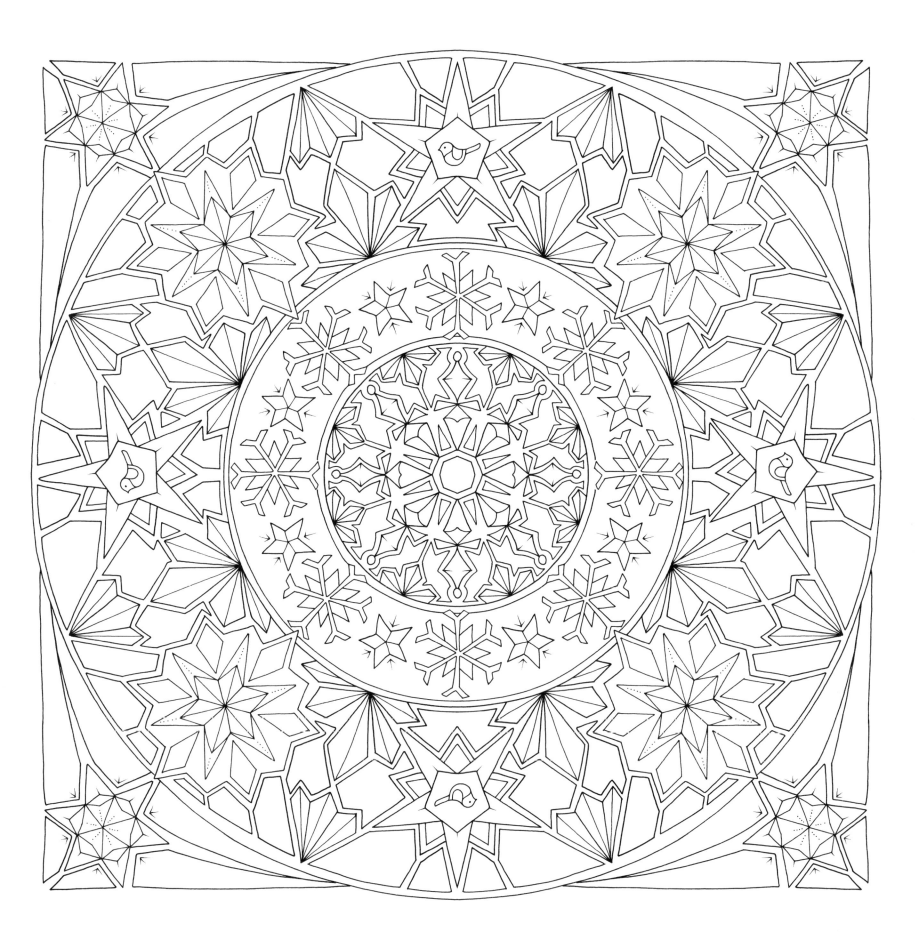

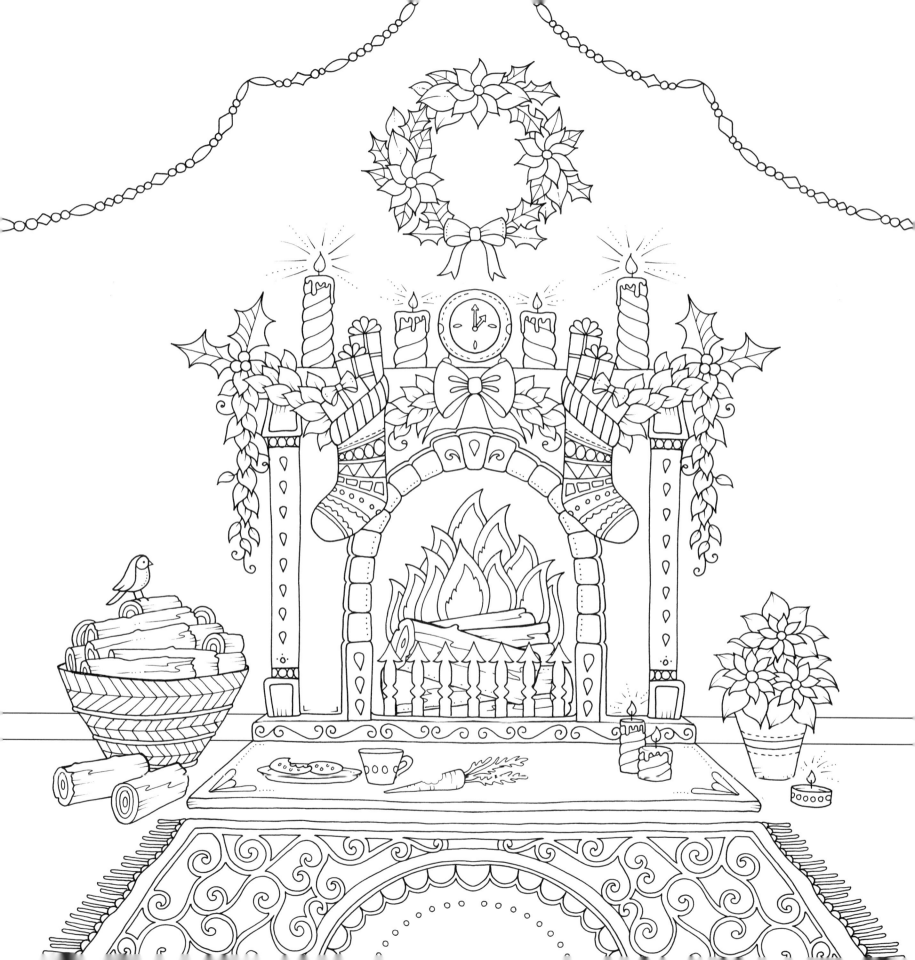

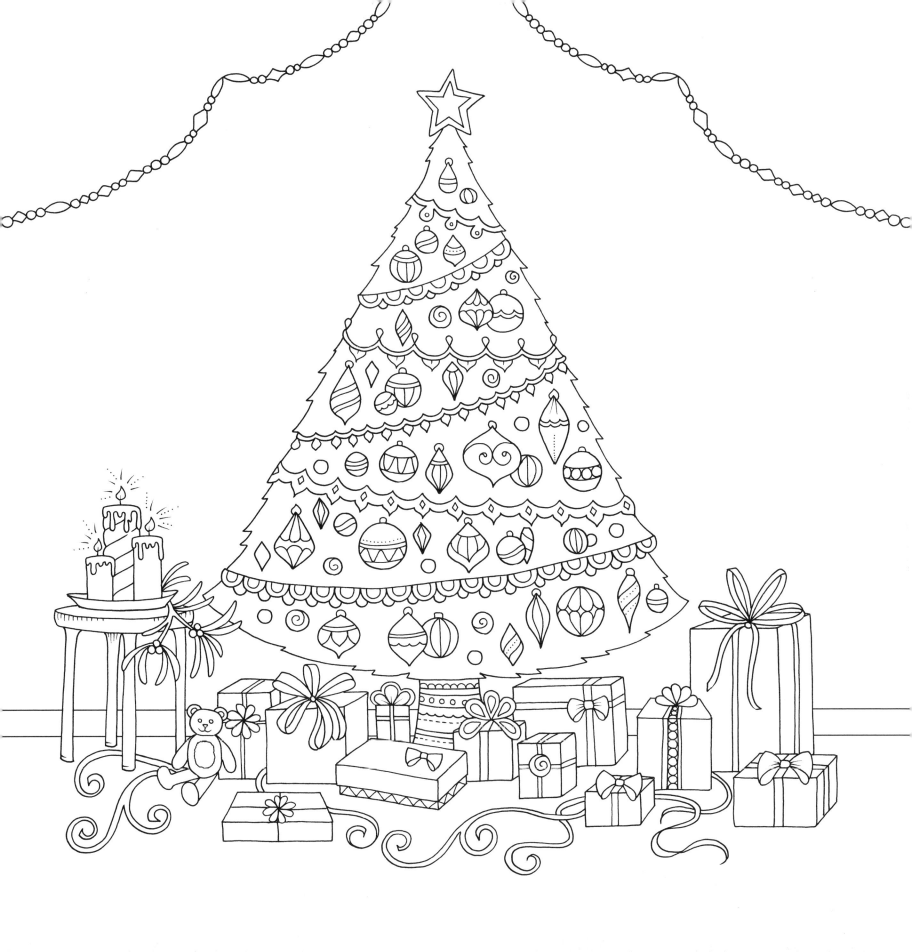

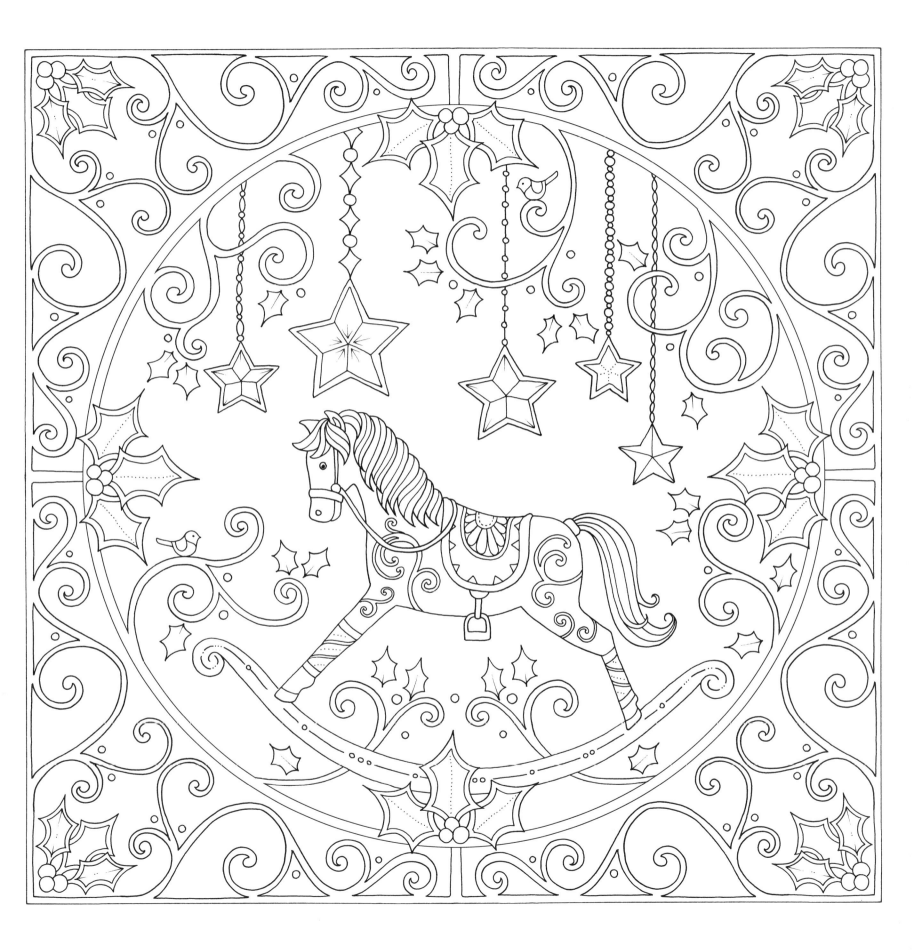

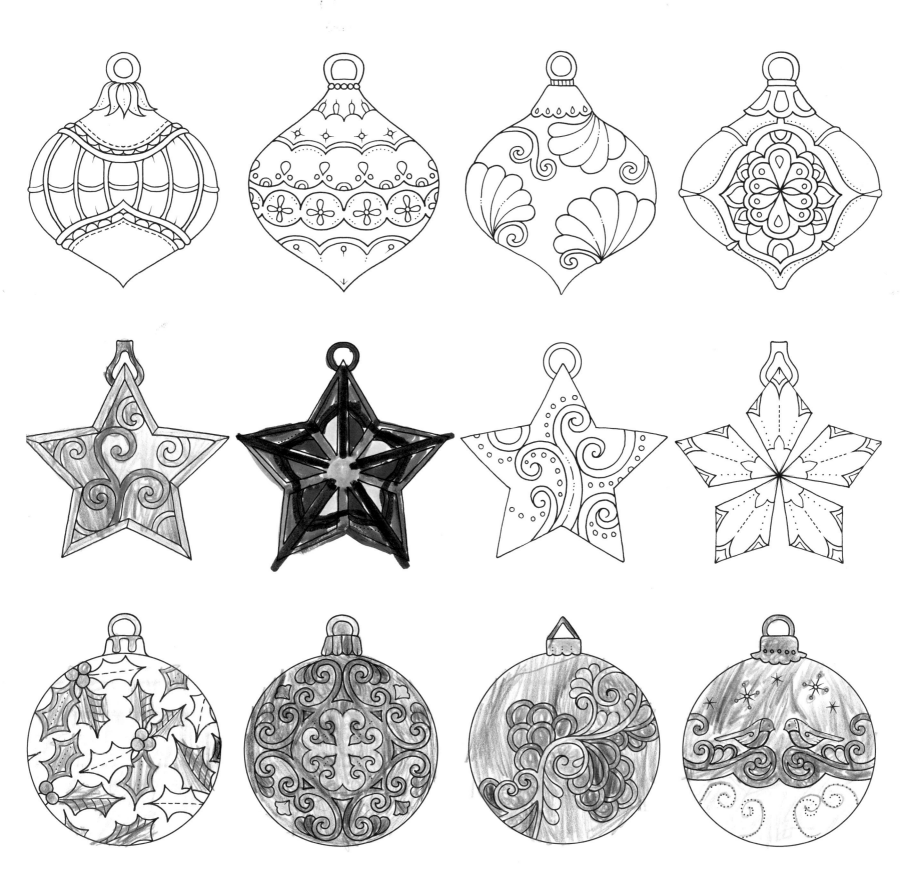

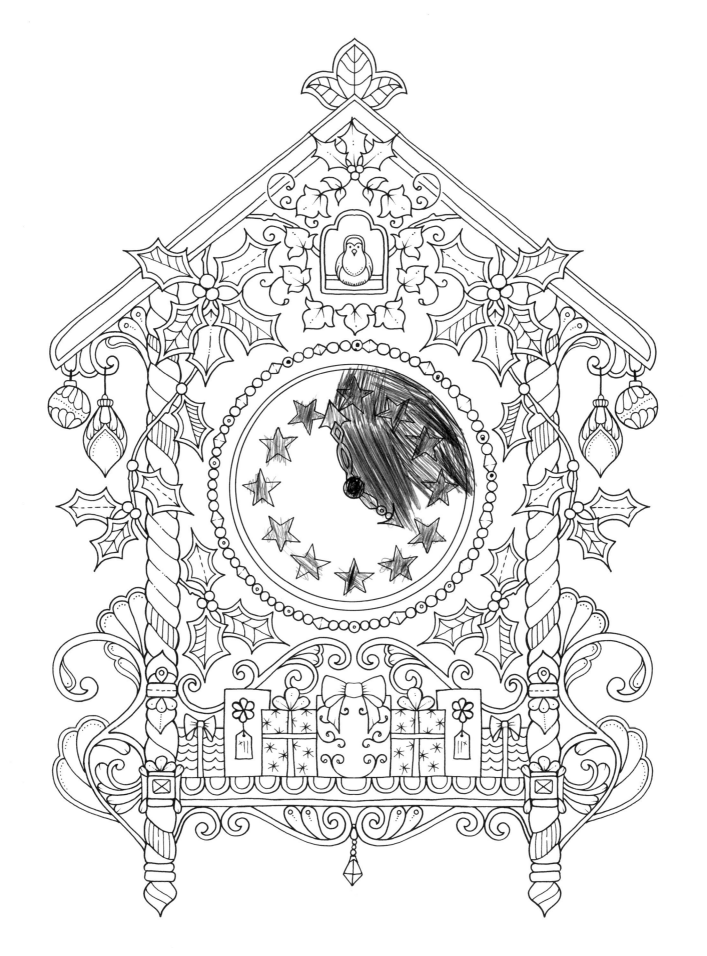

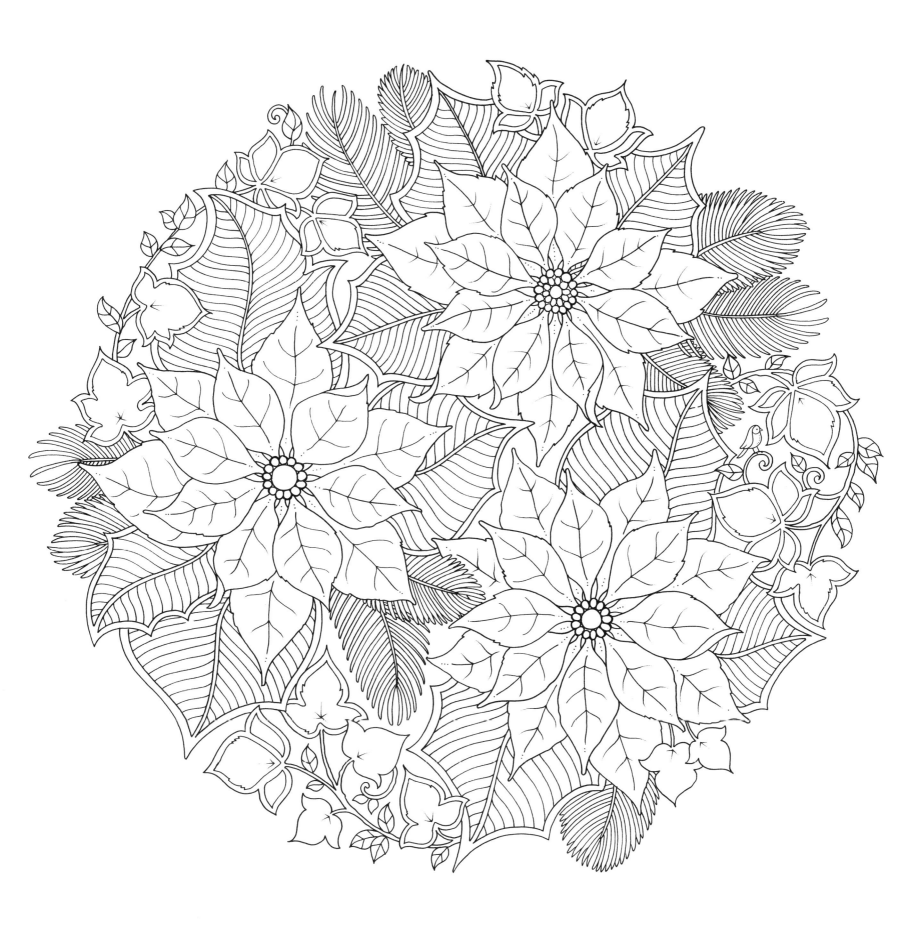

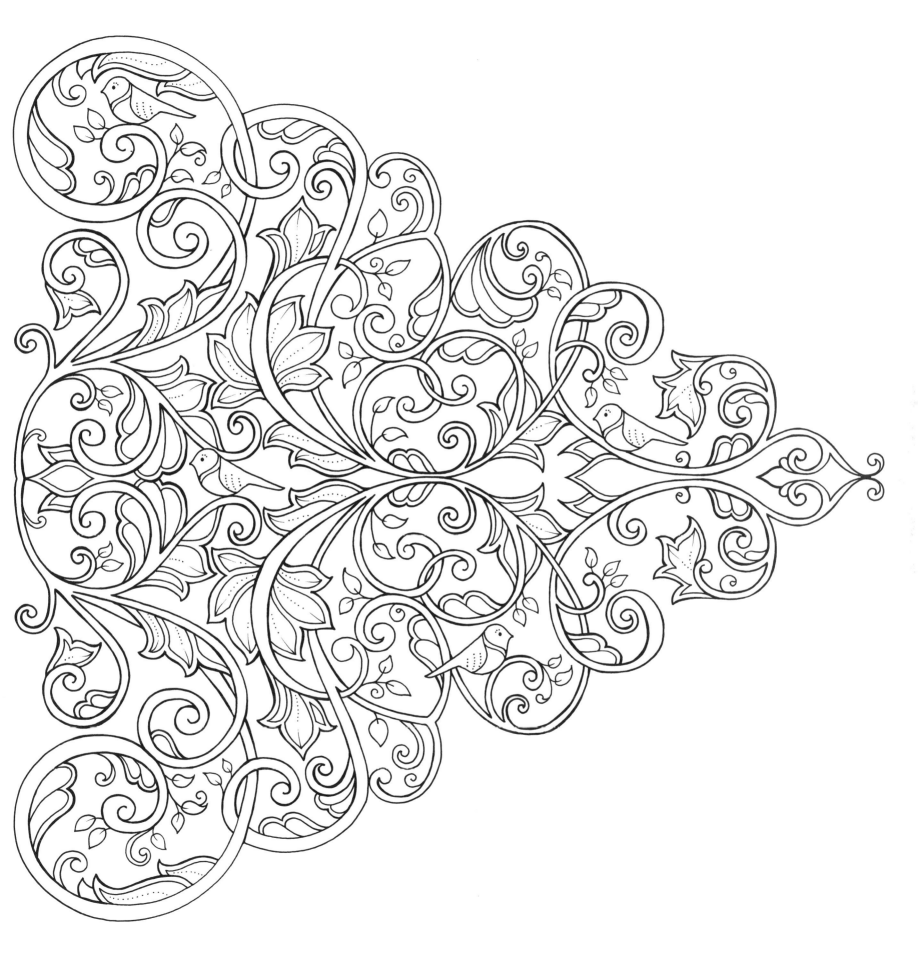

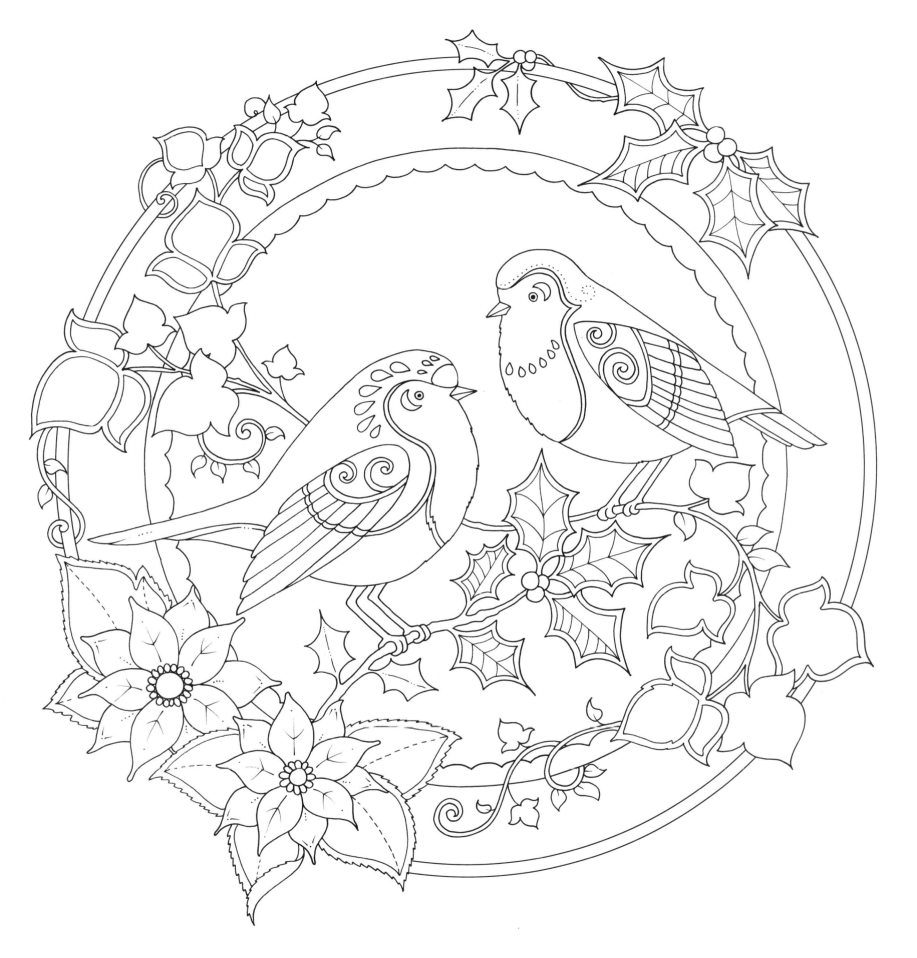

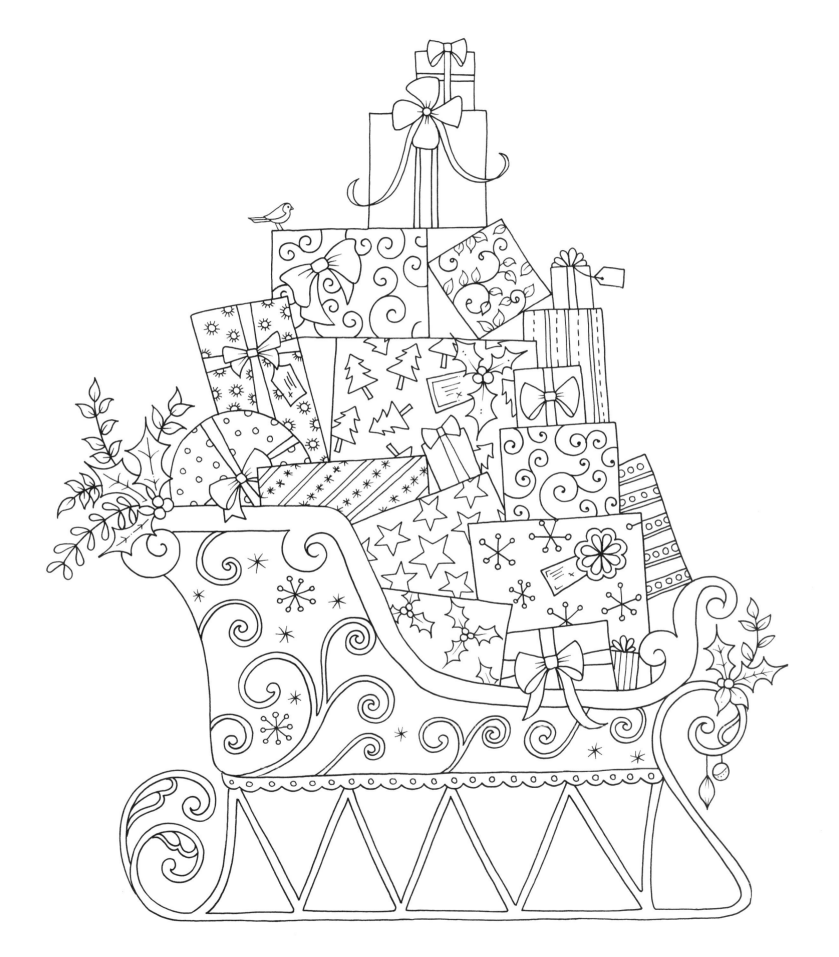

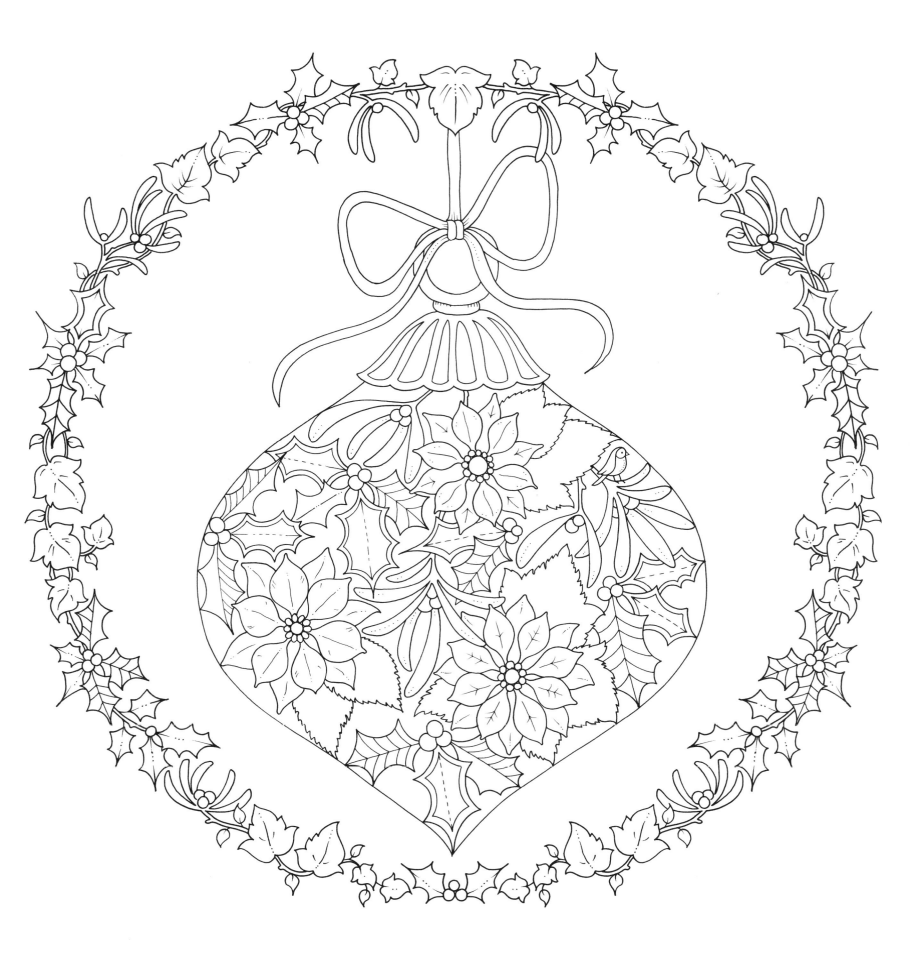

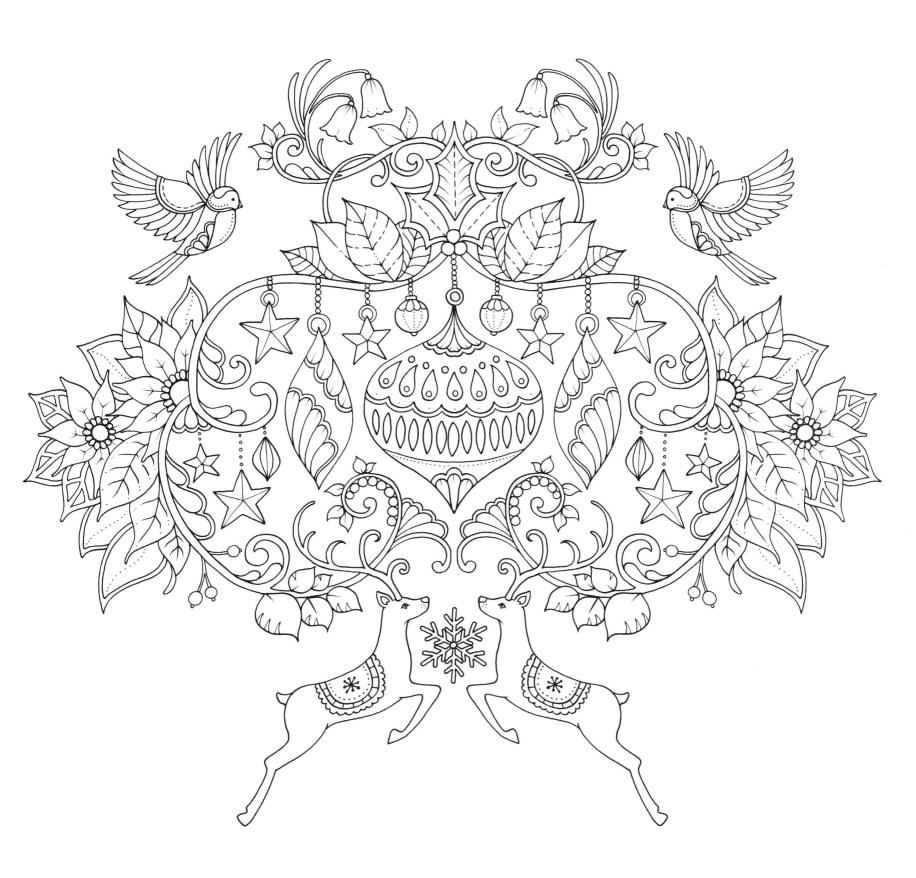

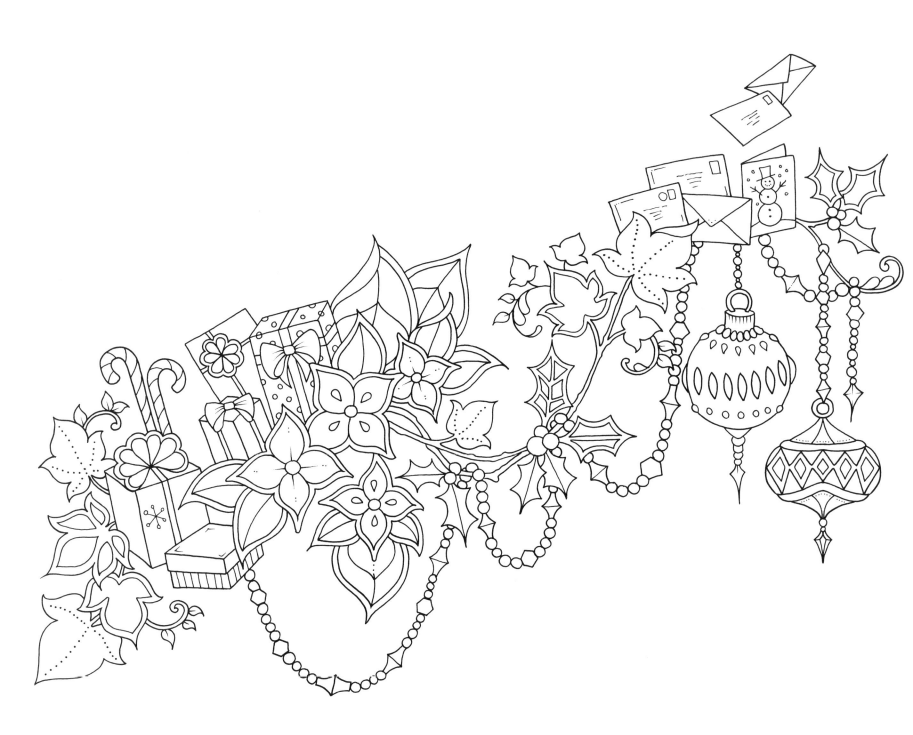

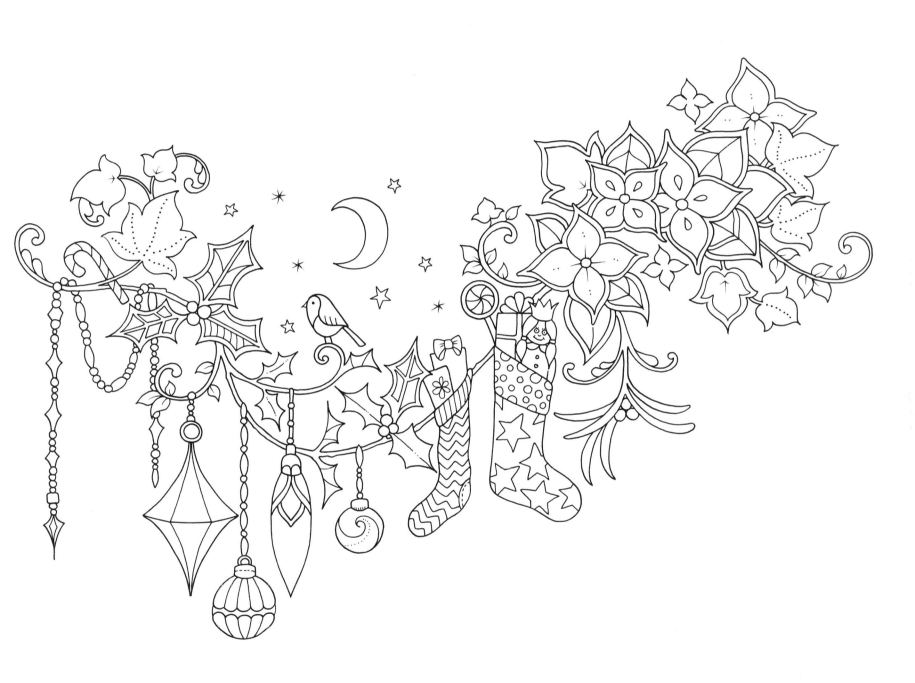

Color Palette Test Page